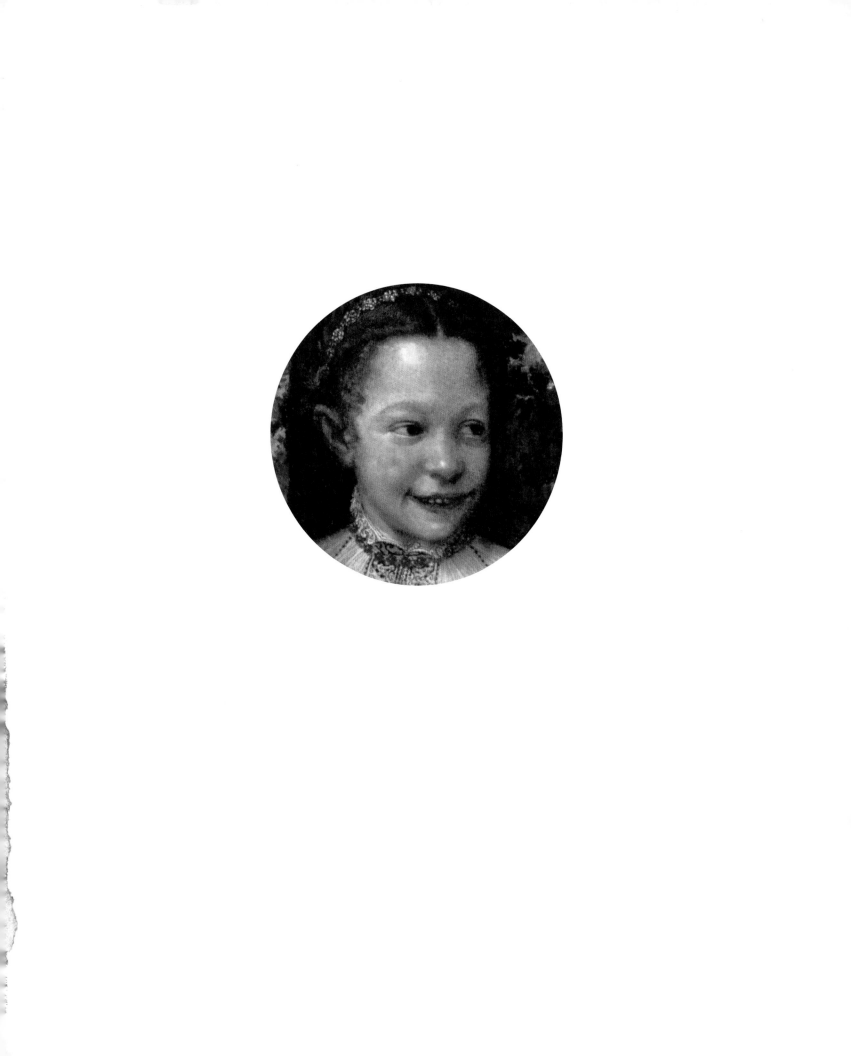

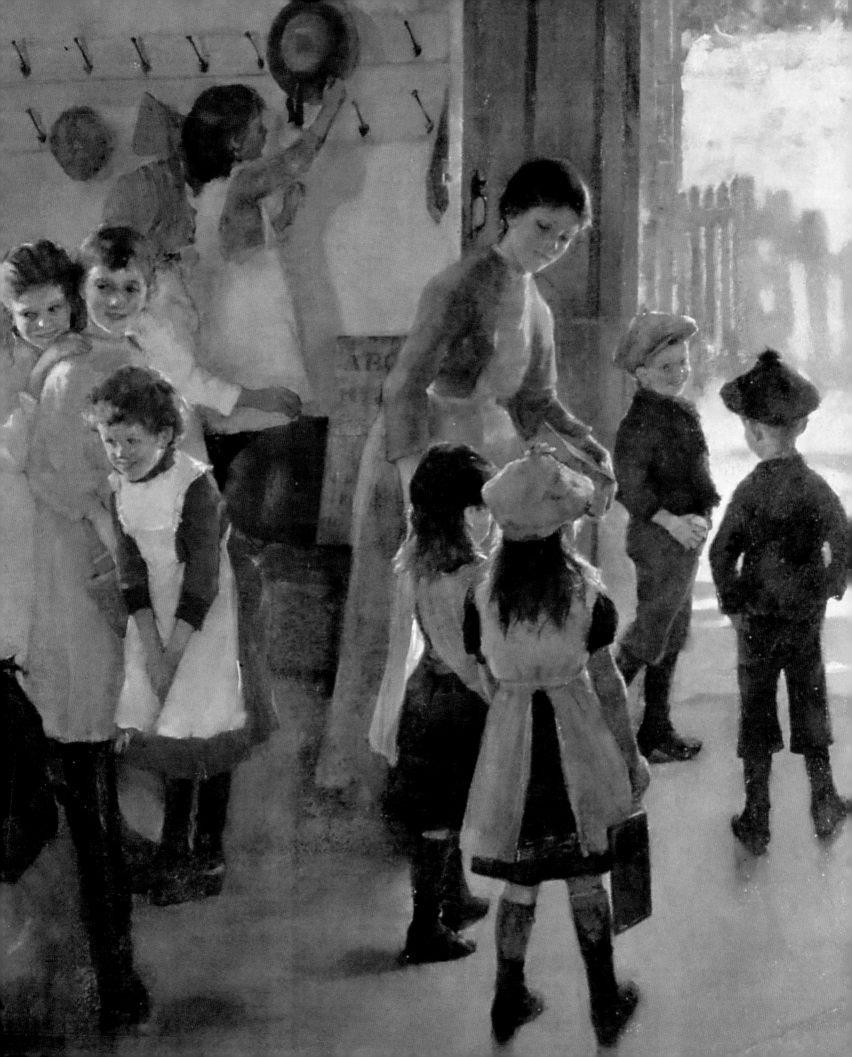

13 Women Artists
Children Should Know

Bettina Schümann

PRESTEL

Munich · Berlin · London · New York

Contents

This

book introduces you to thirteen great women artists. You will learn about the dreams that the thirteen artists followed throughout their lives and discover how these women were able to fulfill them. This book tells you where and when they lived and what they managed to achieve with their art. Almost all of them were successful during their own lifetime, which is not something every artist manages by any means—and for women artists it has always been twice as difficult.

Of course you will also get to know some of their most important works of art. You can answer the quiz questions and find lots of ideas for your own pictures.

The timeline gives you an idea of important events which happened during the lifetime of each artist in this book. And right at the back you will find explanations of terms and names which are marked with an asterisk* in the text. Have fun reading and experimenting!

And just one more thing:
Be careful—
art is infectious!

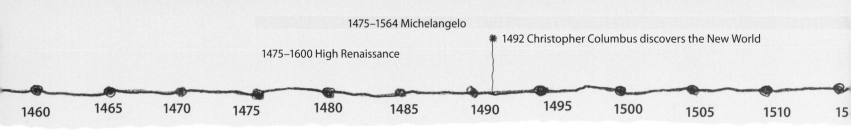

Born:
 1532 in Cremona
Died:
 1625 in Palermo
Lived in:
 Cremona, Madrid,
 Genoa, and Palermo
Children:
 None of her own, but
 her second husband
 had a son by a previ-
 ous marriage
Era:
 Renaissance*

Good to know
A man called Giorgio
Vasari wrote a famous
book about the most
important artists of his
time and it was a great
honor to be included.
He reported enthusias-
tically about Sofonisba:
". . . indeed, the people
she paints seem to
be alive and the only
thing they cannot do is
speak . . ."

Sofonisba Anguissola– The painter of wonderful portraits

Sofonisba Anguissola created magically lively portraits which captured the true character of her subjects. In those days that was something completely new.

Her early works were mostly self-portraits that show her remarkable talent and her great beauty. In order to make Sofonisba famous, her father sent the pictures to the most important royal courts of the time. And so it came about that this young girl from a minor aristocratic family was summoned to the court of King Philip II of Spain who, in those days, ruled over her native Cremona. She was to give fourteen-year-old Queen Isabella painting lessons. She became Isabella's favorite lady-in-waiting.

Sofonisba produced a number of portraits of the Spanish royal family. There were a lot of rules in those days about portrait painting and artists who painted the Queen, for example, had to make sure that she look as dignified as possible. But all the same, Sofonisba always managed to give her pictures a personal touch.

She observed her fellow humans with humor and affection, and chose her subjects to match. One of her pictures shows a little boy crying because he has just been pinched by a crab. His big sister smiles kindly as she comforts him. Portraying scenes like this from everyday life was also something new at that time.

Sofonisba lived during the Renaissance*. It was then that people started to try to paint things according to nature for the first time. And they also began to see how each individual person was unique and important. Girls were allowed to enjoy a proper education—and that was new as well! Sofonisba was lucky to be born at that time.

1532–1625 Sofonisba Anguissola

✳ 1521 Spain conquers the Aztec kingdom in Central America
✳ 1535 Cremona and the rest of Lombardy come under Spanish rule
1527–1598 King Philip II of Spain

1520 1525 1530 1535 1540 1545 1550 1555 1560 1565 1570 1575

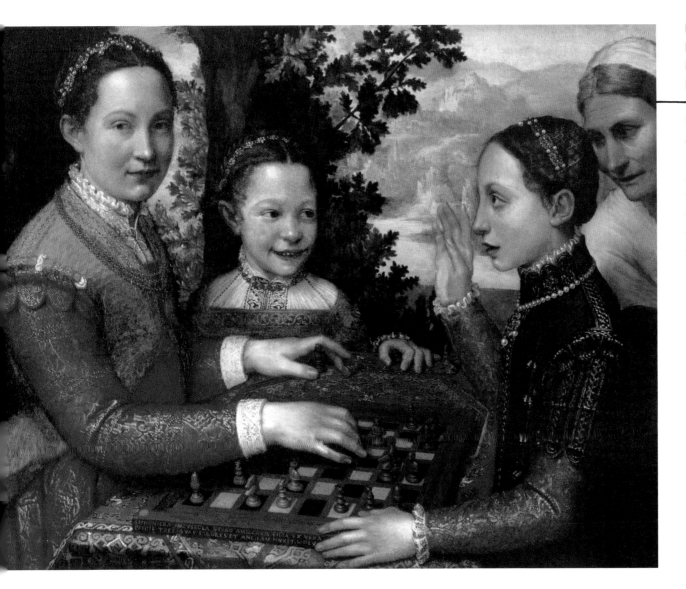

Lucia, Minerva, and Europa Anguissola Playing Chess, 1555
National Museum, Poznań

Here Sofonisba has painted three of her five sisters playing chess—Lucia is on the left, Minerva on the right, and Europa in the middle. A maid is watching them. Look at their faces: can you guess what they are laughing about?

Quiz
Do you agree with Giorgio Vasari? What do you think they might be saying!
You can find some suggestions on page 46.

Would you also like to draw a portrait? Why not have a go! The easiest way to start is to copy a photograph in black and white using a pencil.

1600–1700 The Baroque era
1593–1650 Matthäus Merian the Elder, a famous engraver and Maria Sibylla's father
1618–1648 Thirty Years' War

1575 1580 1585 1590 1595 1600 1605 1610 1615 1620 1625 163

Born:
 April 2, 1647 in
 Frankfurt am Main
Died:
 January 13, 1717
 in Amsterdam
Lived in:
 Frankfurt, Nurem-
 berg, Castle Waltha
 (Frisia), Surinam,
 and Amsterdam
Children:
 Two daughters
Era:
 Baroque*

Maria Sibylla Merian—Butterflies, bugs, and other creepy-crawlies

Maria Sibylla Merian was fascinated by the metamorphosis of a chrysalis into a beautiful butterfly. That even inspired her to travel to tropical Surinam in South America.

What an amazing woman! She had the courage—400 years ago—to do things which would be pretty daring even today. Or would you—assuming you were already grown up—just set sail across the Atlantic to visit the unknown country of Surinam, in order to catch butterflies in the jungle and then preserve and draw them? Maria Sibylla Merian did just that!

At the age of eleven she was already a highly skilled copperplate engraver*. When she was thirteen she first observed the metamorphosis of butterflies at a silk farm. For her it was a "divine miracle!"

Maria Sibylla could not forget about the miracle she had seen. She roamed through the meadows near where she lived in Frankfurt, Germany, and collected caterpillars. At home she put them in jars and boxes—but what do caterpillars eat? Imagine her joy when another butterfly emerged! The Church regarded insects as "the Devil's creatures" and the neighbors started to gossip: "She's a witch!" they said—which was dangerous as there were still witch hunts* at that time. But Maria Sibylla refused to be put off. She observed and drew one "divine miracle" after the other.

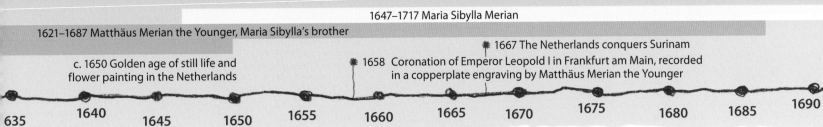

1647–1717 Maria Sibylla Merian

1621–1687 Matthäus Merian the Younger, Maria Sibylla's brother

✱ 1667 The Netherlands conquers Surinam

c. 1650 Golden age of still life and
flower painting in the Netherlands

✱ 1658 Coronation of Emperor Leopold I in Frankfurt am Main, recorded
in a copperplate engraving by Matthäus Merian the Younger

635 1640 1645 1650 1655 1660 1665 1670 1675 1680 1685 1690

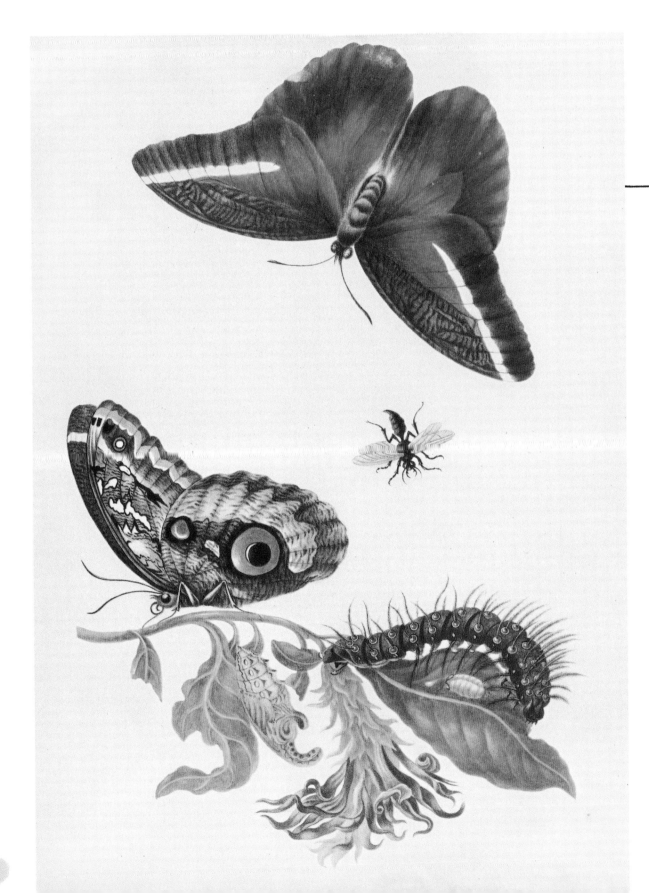

**Attacus Atlas (Moth
and Pupa), Wild Wasp,
Caterpillar of a Saturniid
Moth, 1700–02**
St. Petersburg Watercolors,
Russian Academy of
Sciences, St. Petersburg

Maria Sibylla discovered
that each butterfly con-
centrates on one particu-
lar type of plant for its
food. It lays its eggs on
that plant and the cater-
pillars eat the leaves and
grow big and fat before
developing into a chrysa-
lis and finally emerging
as a butterfly. That is
why Maria Sibylla always
painted the plant which
was the source of food
together with the creature
in all its stages of develop-
ment.

**Darevskia Lizard,
Great Earless Lizard,
Surinam Ameiva, Gecko,
1699–1701**
St. Petersburg Watercolors,
Russian Academy of
Sciences, St. Petersburg

During her trip to Surinam,
Maria Sibylla was not only
interested in butterflies.
Look how carefully she
made these drawings and
then colored them using
watercolors. Her drawings
served as templates for
copperplate engravings*
which could then be
printed.

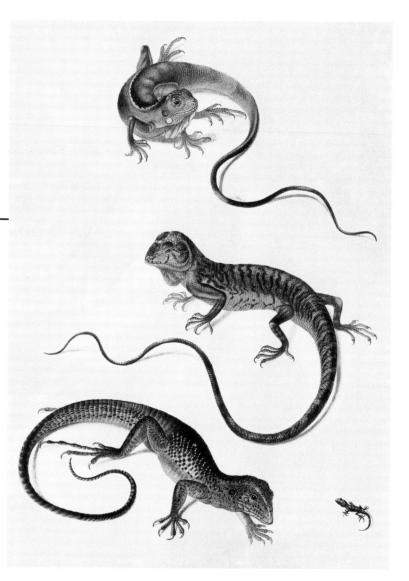

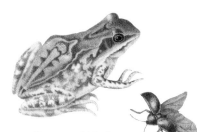

**Frog and Various
Insects, before 1699 or
after 1702**
St. Petersburg Watercolors,
Russian Academy of
Sciences, St. Petersburg

Maria Sibylla's curiosity
was aroused by every-
thing which buzzed,
crawled, or hummed.

Tips
You can find out all about
butterflies and where and
when you can see tropi-
cal butterflies near your
home from this UK web-
site: www.ukbutterflies.
co.uk or in the USA: www.
butterfliesandmoths.org

Some of the butterflies
prepared by Maria Sibylla
in Surinam have sur-
vived for 400 years and
can still be seen today.
They form part of the
"Gerning Collection"
in the Landesmuseum
Wiesbaden in Germany.

One day Maria Sibylla had the chance to see examples of the most
beautiful tropical butterflies from Surinam. It was a sight which filled her
with a longing to go on a voyage of exploration to that very place! She was
the very first person to carry out such a plan.

She set sail for South America with her younger daughter. The two women
spent two years in Surinam. Indians helped them to clear paths through
the jungle so that they could watch and draw the animals and plants. Then
Maria Sibylla became seriously ill with malaria and she and her daughter
had to return to Amsterdam.

1521 Spain conquers the Aztec kingdom in Central America

1535 Cremona and the rest of Lombardy come under Spanish rule

1527–1598 King Philip II of Spain

1520 1525 1530 1535 1540 1545 1550 1555 1560 1565 1570 1575

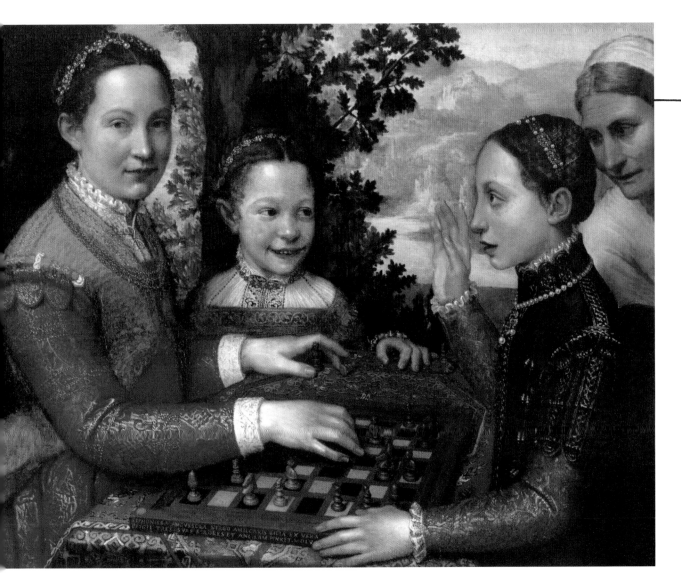

Lucia, Minerva, and Europa Anguissola Playing Chess, 1555
National Museum, Poznań

Here Sofonisba has painted three of her five sisters playing chess—Lucia is on the left, Minerva on the right, and Europa in the middle. A maid is watching them. Look at their faces: can you guess what they are laughing about?

Quiz
Do you agree with Giorgio Vasari? What do you think they might be saying!
You can find some suggestions on page 46.

Would you also like to draw a portrait? Why not have a go! The easiest way to start is to copy a photograph in black and white using a pencil.

1600–1700 The Baroque era
1593–1650 Matthäus Merian the Elder, a famous engraver and Maria Sibylla's father
1618–1648 Thirty Years' War

1575 1580 1585 1590 1595 1600 1605 1610 1615 1620 1625 163

Born:
April 2, 1647 in
Frankfurt am Main
Died:
January 13, 1717
in Amsterdam
Lived in:
Frankfurt, Nurem-
berg, Castle Waltha
(Frisia), Surinam,
and Amsterdam
Children:
Two daughters
Era:
Baroque*

Maria Sibylla Merian–Butterflies, bugs, and other creepy-crawlies

Maria Sibylla Merian was fascinated by the metamorphosis of a chrysalis into a beautiful butterfly. That even inspired her to travel to tropical Surinam in South America.

What an amazing woman! She had the courage—400 years ago—to do things which would be pretty daring even today. Or would you—assuming you were already grown up—just set sail across the Atlantic to visit the unknown country of Surinam, in order to catch butterflies in the jungle and then preserve and draw them? Maria Sibylla Merian did just that!

At the age of eleven she was already a highly skilled copperplate engraver*. When she was thirteen she first observed the metamorphosis of butterflies at a silk farm. For her it was a "divine miracle!"

Maria Sibylla could not forget about the miracle she had seen. She roamed through the meadows near where she lived in Frankfurt, Germany, and collected caterpillars. At home she put them in jars and boxes—but what do caterpillars eat? Imagine her joy when another butterfly emerged! The Church regarded insects as "the Devil's creatures" and the neighbors started to gossip: "She's a witch!" they said—which was dangerous as there were still witch hunts* at that time. But Maria Sibylla refused to be put off. She observed and drew one "divine miracle" after the other.

1647–1717 Maria Sibylla Merian

1621–1687 Matthäus Merian the Younger, Maria Sibylla's brother

1667 The Netherlands conquers Surinam

c. 1650 Golden age of still life and flower painting in the Netherlands

**1658 Coronation of Emperor Leopold I in Frankfurt am Main, recorded in a copperplate engraving by Matthäus Merian the Younger

635 1640 1645 1650 1655 1660 1665 1670 1675 1680 1685 1690

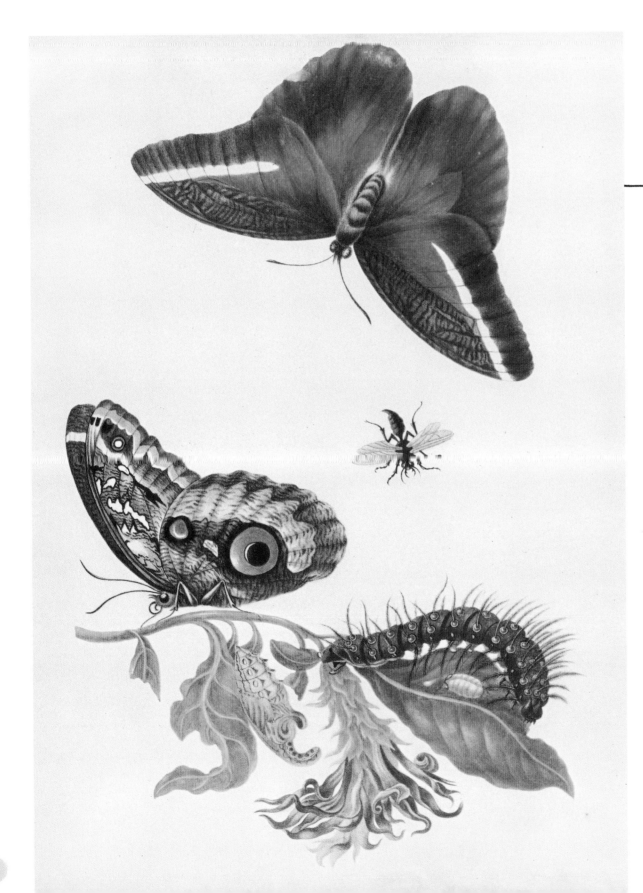

Attacus Atlas (Moth and Pupa), Wild Wasp, Caterpillar of a Saturniid Moth, 1700–02
St. Petersburg Watercolors, Russian Academy of Sciences, St. Petersburg

Maria Sibylla discovered that each butterfly concentrates on one particular type of plant for its food. It lays its eggs on that plant and the caterpillars eat the leaves and grow big and fat before developing into a chrysalis and finally emerging as a butterfly. That is why Maria Sibylla always painted the plant which was the source of food together with the creature in all its stages of development.

**Darevskia Lizard,
Great Earless Lizard,
Surinam Ameiva, Gecko,
1699–1701**
St. Petersburg Watercolors,
Russian Academy of
Sciences, St. Petersburg

During her trip to Surinam,
Maria Sibylla was not only
interested in butterflies.
Look how carefully she
made these drawings and
then colored them using
watercolors. Her drawings
served as templates for
copperplate engravings*
which could then be
printed.

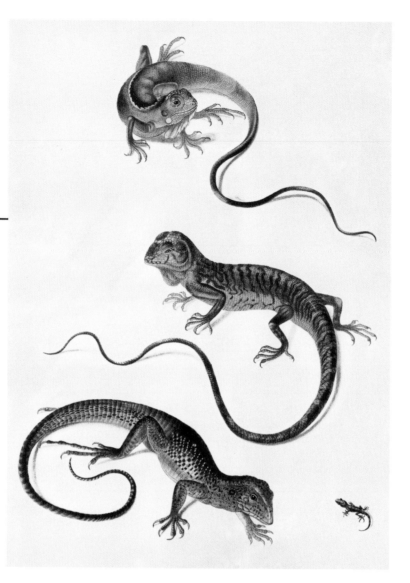

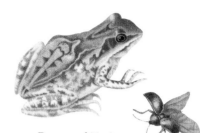

**Frog and Various
Insects, before 1699 or
after 1702**
St. Petersburg Watercolors,
Russian Academy of
Sciences, St. Petersburg

Maria Sibylla's curiosity
was aroused by every-
thing which buzzed,
crawled, or hummed.

Tips
You can find out all about
butterflies and where and
when you can see tropi-
cal butterflies near your
home from this UK web-
site: www.ukbutterflies.
co.uk or in the USA: www.
butterfliesandmoths.org

Some of the butterflies
prepared by Maria Sibylla
in Surinam have sur-
vived for 400 years and
can still be seen today.
They form part of the
"Gerning Collection"
in the Landesmuseum
Wiesbaden in Germany.

One day Maria Sibylla had the chance to see examples of the most
beautiful tropical butterflies from Surinam. It was a sight which filled her
with a longing to go on a voyage of exploration to that very place! She was
the very first person to carry out such a plan.

She set sail for South America with her younger daughter. The two women
spent two years in Surinam. Indians helped them to clear paths through
the jungle so that they could watch and draw the animals and plants. Then
Maria Sibylla became seriously ill with malaria and she and her daughter
had to return to Amsterdam.

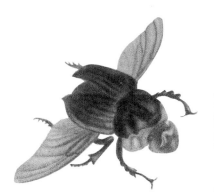

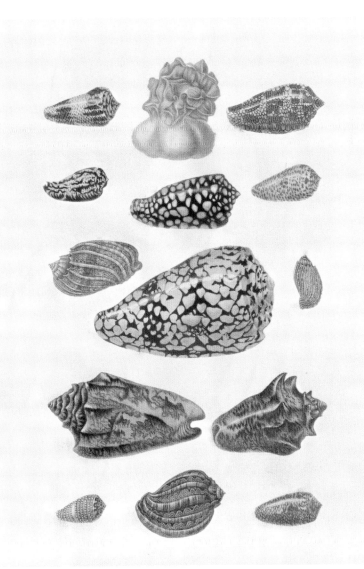

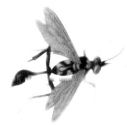

Prosobranchiae: Cone Snail, Limpet, and Volute, 1704/05
St. Petersburg Watercolors, Russian Academy of Sciences, St. Petersburg

Strange creatures like these snails were brought back to Europe from far-away colonies*. The artists of the time were inspired by them to paint still lifes*.

But in their luggage they had a real hoard of preserved animals and insects as well as lots of drawings which they displayed in their house in Amsterdam. Many visitors came to marvel at the exhibition. Then Maria Sibylla produced her most magnificent work: *Metamorphosis Insectorium Surinamensium*, illustrated with lots of engravings, detailed descriptions, and scientific observations.

What would your most beautiful butterfly look like?

Good to know
There is a "Maria Sibylla Merian Prize", which is awarded every year to two young women artists with the aim of supporting talented young women artists.

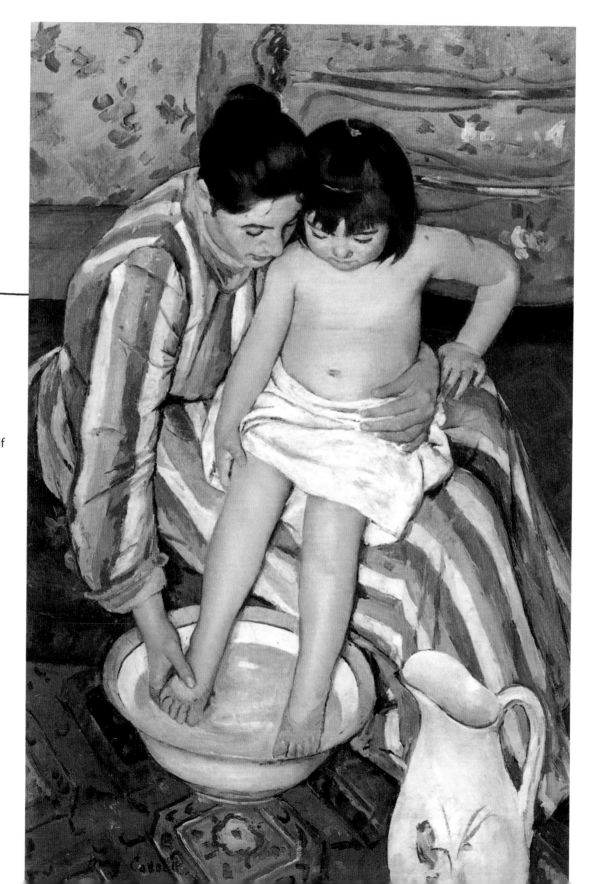

**The Child's Bath
(La Toilette), 1893**
The Art Institute of
Chicago

A mother is tenderly
washing her daughter's
feet. Both of them are
totally concentrating on
each other and aren't
taking any notice of what
is going on around them.
It really makes you feel as if
you are secretly watching
them without their
knowledge, doesn't it?
That is because of the
unusual angle from
diagonally above them
which Mary chose.

Mary Cassatt– The Impressionists' friend

Born:
May 22, 1845 in Allegheny near Pittsburgh, USA
Died:
June 14, 1926 in Mesnil-Théribus, France
Children:
None
Style:
Impressionism*

She was gifted, famous, and wealthy. Mary Cassatt was an American artist who chose mostly to paint women—especially mothers with their children.

Once she had put her mind to something, Mary could be quite stubborn. Her father felt the full force of it; he was not at all pleased that his daughter had decided to become an artist. But she insisted on having her own way and that was a good thing as her work would be compared with that of the best artists of her time.

Mary spent most of her life in Europe. At that time, Impressionism* was just coming into fashion in Paris, which was the art capital in those days. Arriving from America, Mary was full of enthusiasm for this style of painting. She became friendly with some of the Impressionist painters and exhibited her work alongside theirs. Her bright pictures, full of shimmering colors, delighted the public too. She soon became famous—despite being not only a foreigner, but a woman too. It was a really unusual career at that time!

As she grew older, Mary's eyesight failed and she had to stop painting. Nonetheless, she continued to support Impressionist art actively. It was thanks to her that some of her fellow artists also became famous in America.

Another new thing was that the Impressionists went outside to paint. Where would you choose to go to paint nature? Which tree, stream, or park is your favorite?

A Woman and a Girl Driving, 1881
Philadelphia Museum of Art

Wild horses couldn't stop these two as they drive along together. The man in the background hardly seems to be of any importance at all. Mary often showed women as active and determined—not just young and pretty. That was something new at the time.

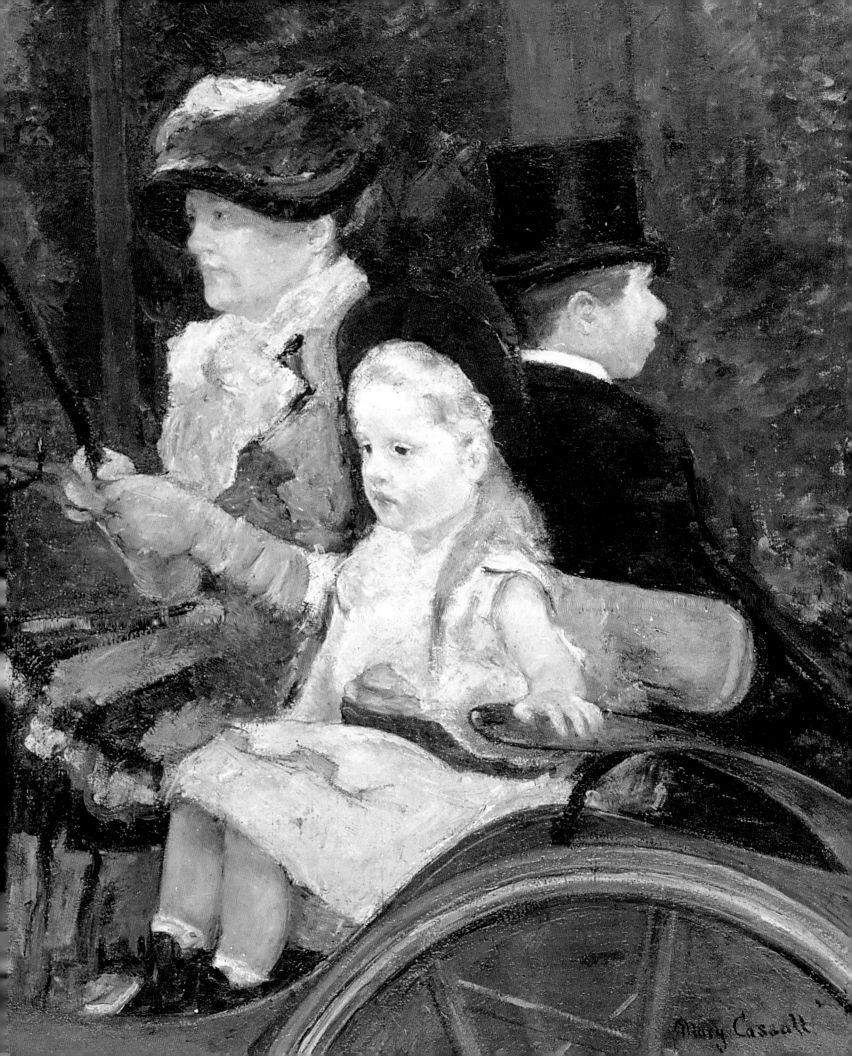

The Minuet, 1892
Penlee House, Penzance,
Cornwall

The minuet is an old
French folk dance which
was popular until well
into the nineteenth cen-
tury. Here, the people
are dancing at home.
Look carefully to see how
many reflections and
sources of light you can
see in this picture.

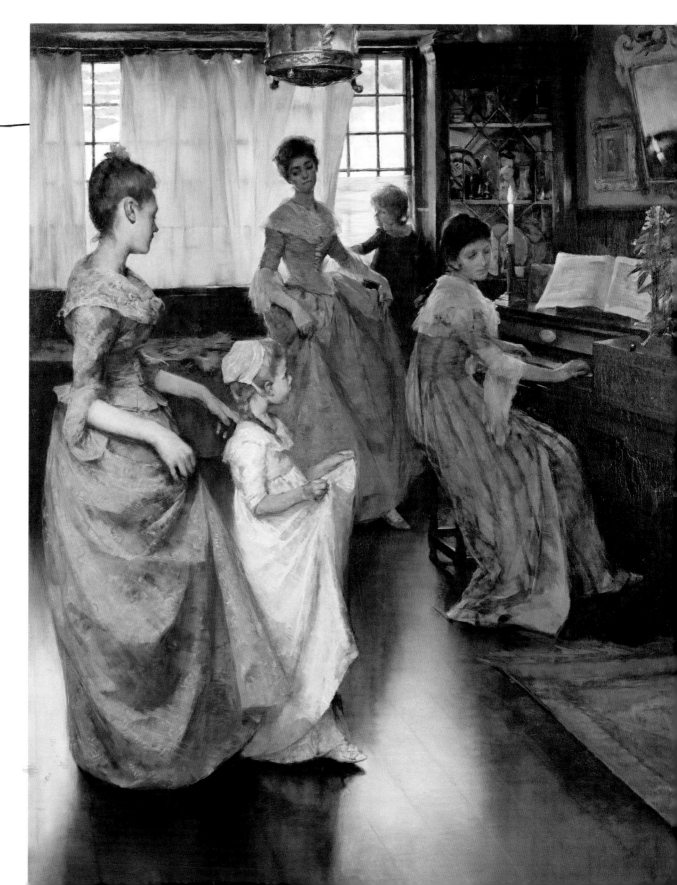

Elizabeth Armstrong Forbes— Children were her favorite subject

Elizabeth Armstrong Forbes went traveling in order to learn how to paint. In the end she found the place where she really belonged.

What could be nicer that to live with friends in a pretty village by the sea and to spend your time with them doing what you like best in the whole world: painting? Elizabeth was lucky enough to do just that. She settled in the artists' colony* in Newlyn, Cornwall, in the southwest of England. She became successful and was a recognized artist. She even founded a painting school of her own in Newlyn. However, before she settled down she traveled a great deal between Canada, England, the United States, Germany, France, and the Netherlands.

Born:
December 29, 1859 in Kingston, Canada
Died:
March 16, 1912 in Newlyn, Cornwall, England
Lived in:
Canada, London, New York, Munich, Pont-Aven (Brittany, France), Zandvoort (Holland), Newlyn
Children:
One son
Painting style:
Impressionism*

Elizabeth was born in Canada. When she was eighteen she left for London and attended Kensington Arts School before going to the Arts Students League in New York, where she positively soaked up new ideas. They painted outdoors in the open air where they could see the light changing at different times of day and look at the colors of the landscape at different seasons of the year.

Tip
You can see pictures by the Newlyn artists in Penlee House Gallery and Museum, Morrab Road, Penzance, Cornwall, England.

For one year Elizabeth lived in the artists' colony of Pont-Aven in France. Although her future husband, Stanhope Forbes, was there at the same time, they didn't actually meet there, but four years later in England at the artists' colony in Newlyn. They were married in 1889—in the year in which Elizabeth painted her most famous picture *School is Out*. It was in this picture that she discovered her favorite subject: children.

Quiz

Which new industrial product enabled artists to paint their pictures outdoors?

(Answer on page 46)

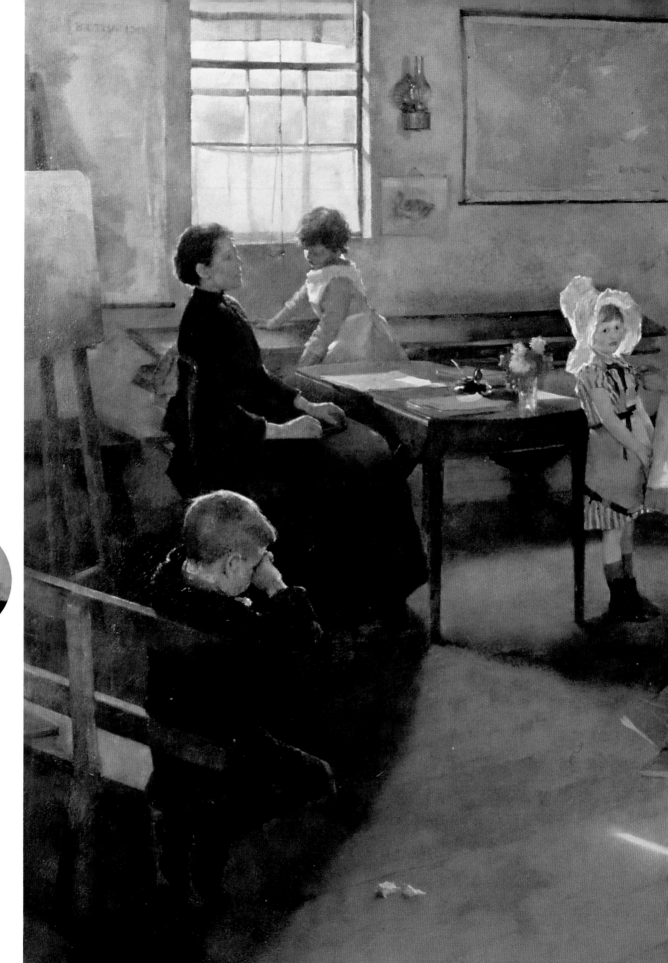

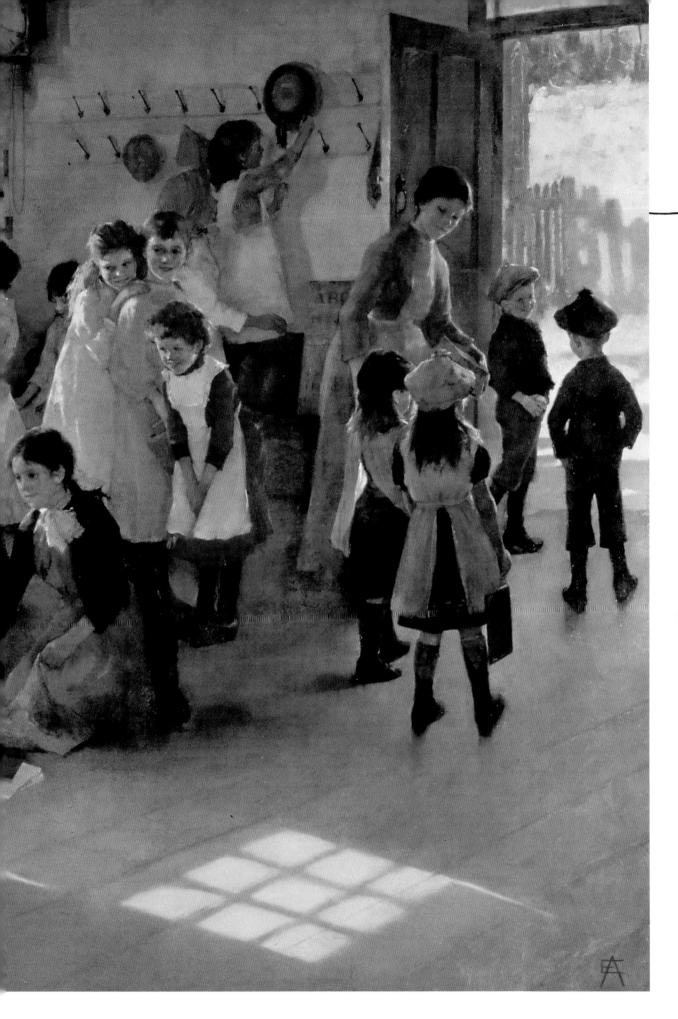

School is Out, 1889
Penlee House, Penzance, Cornwall

How lovely the sunshine looks outside! Its rays are filtering into the classroom and the play of light and shade has been carefully worked out. In Impressionism*—which is the painting style to which this picture belongs—the artists often tried to capture the various moods of light.

1864–1946 Alfred Stieglitz, Georgia's husband

1857–1922 Arthur Wesley Dow

1846–1848 The state of New Mexico and other territories
are ceded to the United States by Mexico

✳ 1875 Founding of the Art Students League of New York

| 1840 | 1845 | 1850 | 1855 | 1860 | 1865 | 1870 | 1875 | 1880 | 1885 | 1890 | 18 |

Born:

November 15, 1887 on her parents' farm near the little town of Sun Prairie in Wisconsin

Died:

March 6, 1986 in Santa Fe, New Mexico

Lived in:

Sun Prairie, Williamsburg (Virginia), Chicago, New York City, Texas, South Carolina, New York State, New Mexico

Children:

None

Style:

Abstract* or representational in abstract, compositional style

Georgia O'Keeffe – The artist in the desert

With her mysterious pictures Georgia O'Keeffe wanted to make people more aware of the "wonders of our world."

Whenever possible Georgia left home and roamed the countryside. She only had to open the door and she was surrounded by nature—the forests, the meadows and fields, or the shores of one of the numerous lakes. She found incredible treasures everywhere: stones, grasses, blossoms, shells, pieces of wood . . .

At the age of twelve she realized that she wanted to become an artist and went on to study at the best art schools in Chicago and New York. But at the same time she had a sort of empty feeling inside. Technically her work was perfect. But who could provide her with an answer to the question as to how she could paint what she actually felt?

She found the answer when she met the artist Arthur Wesley Dow. For him it was perfectly clear: Pictures should be "composed" like a piece of music—but with colors and lines instead of sounds and melodies. A picture contains rhythms just like music. And the shapes should be clear and simple, so that the "essence" of an object could be clearly seen.

And so it was that Georgia found her own unique form of expression: she "painted music" in colors and shapes. And she also painted luminous landscapes and ripe fruits. She sometings painted tiny things very large— so big that they were hardly recognizable. She wanted to persuade people to look more carefully! Her enormous flower pictures, in particular, became famous. We find ourselves looking into the inside of a humongous open flower as if through a zoom.

1914–1918 World War I

1939–1945 World War II

1900 1905 1910 1915 1920 1925 1930 1935 1940 1945 1950 1955

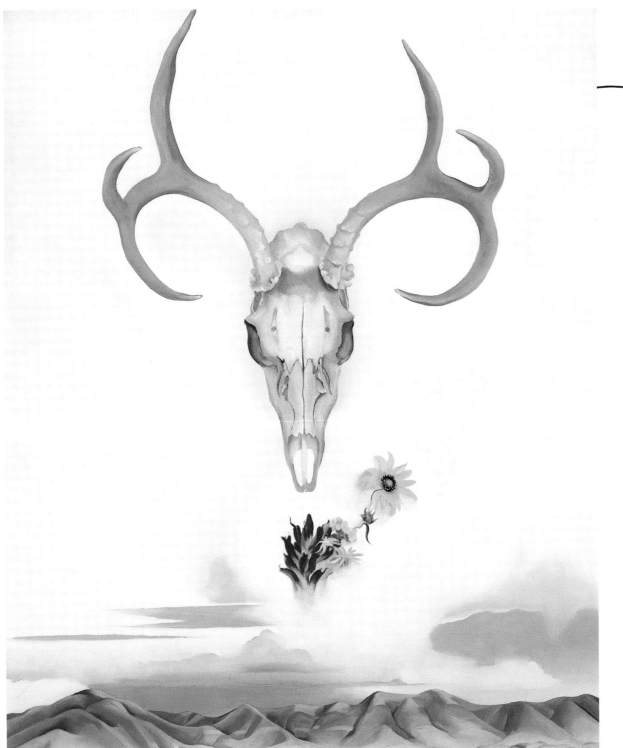

Summer Days, 1936
Whitney Museum of American Art, Gift of Calvin Klein, New York

How do the things in this picture fit together? A deer skull hovers in the sky and luminous flowers are growing in a red desert. How strange!

Georgia often found skulls like this one in the desert. Although they remind us that death is ever-present in this merciless landscape, for Georgia the bones stood for vitality. And with it she painted these brilliantly-colored flowers—are they made of fabric, perhaps? The Spanish inhabitants of New Mexico use flowers like these ones, made of fabric, to decorate graves. The rules of "above, below, near, and far" seem to have been cancelled out in the shimmering desert light.

Oriental Poppies, 1927
The Frederick R. Weisman
Art Museum, University
of Minnesota, Minnesota

What a brilliant shining
red! For Georgia, colors
were one of the things
which made life worth
living. Do you think she
was trying to pass on this
feeling to us too?

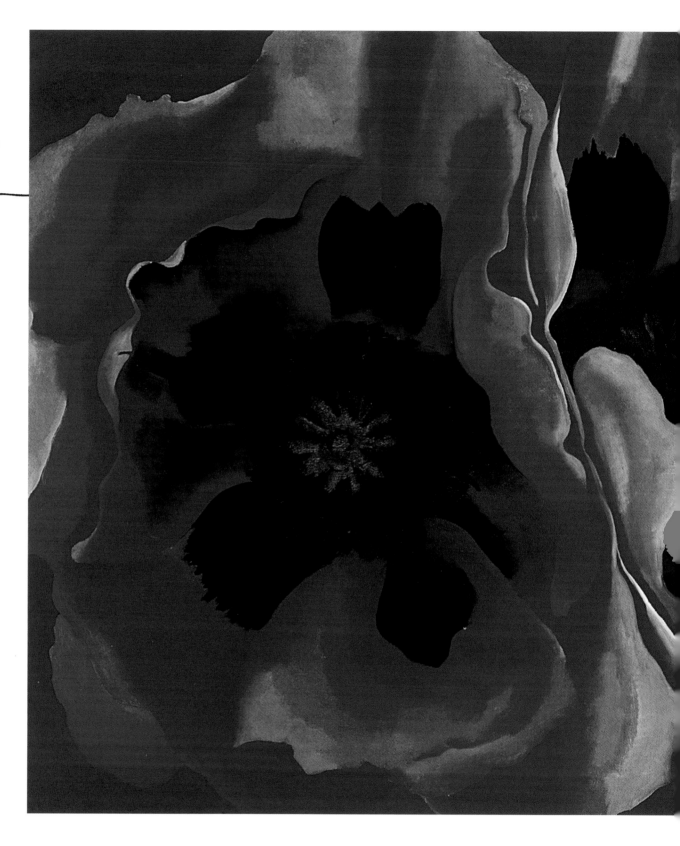

On one trip she discovered the magnificent landscape of New Mexico and
realized she was happiest surrounded by its endless expanse. Even when
she was still living in New York with her husband, the photographer Alfred
Stieglitz, she kept going back there. Later on she fulfilled her dream of

Georgia was fascinated by Arthur Wesley Dow's idea of painting to music. Why don't you try it too?

First choose a suitable CD—classical music is best. Then take a sheet of paper and some crayons. Make sure you have plenty of space—and begin. You can draw soft lines, zigzags, dots, circles, spirals—whatever goes best with the music. You can draw in color or just in pencil and then color in your picture later on if you like!

living in the desert and renovated two houses where she could live near Ghost Ranch. There she never tired of painting her feelings in the face of this unique natural setting.

Tip
Georgia painted the land-scape of New Mexico so often that the region where she lived is now known as "O'Keeffe Country" to this day. In her house you can see a collection of her paintings. But since for most of us it's a bit far to go to just "drop by" you can also see them on the internet at www.okeeffemuseum.org!

21

1845 1850 1855 1860 1865 1870 1880 1885 1890 1895 1900 190

Portait of a Woman, 1915
Museum Ludwig, Cologne

This abstract picture is made up of colors and shapes. But can you make out the shape of the "woman?"

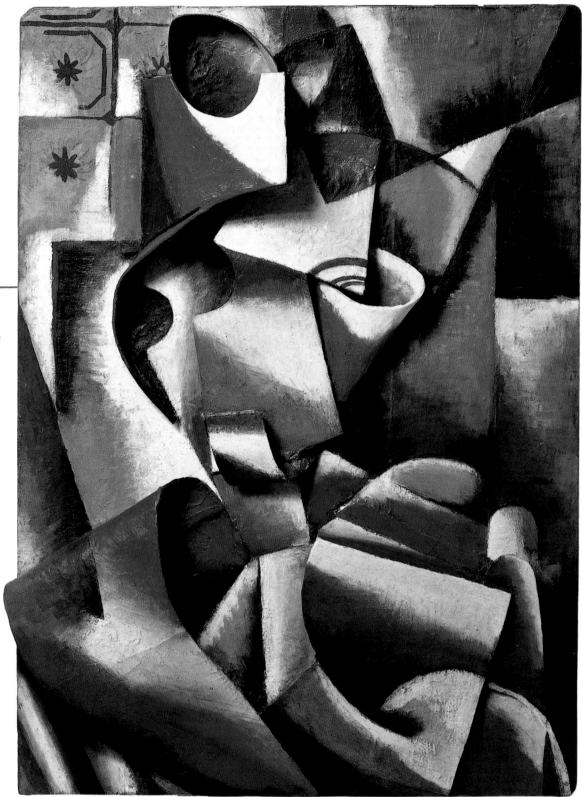

✸ 1917 The Tsar is forced to flee. During the October Revolution the Communist Party seizes power

1914–1918 World War I

1910–1922 Russian Avant-Garde

1910　　1915　　1920　　1925　　1930　　1935　　1940　　1945　　1950　　1955　　1960　　1965

Lyubov Popova– Reshaping the world with art

As an artist of the Russian Avant-Garde*, Lyubov Popova overturned everything within a few years which, until then, had been considered to be correct, beautiful, and good.

Born:
April 24, 1889 in the village of Ivanovskoe near Moscow
Died:
May 25, 1924 of scarlet fever
Lived in:
Ivanovskoe, Moscow, Italy, and Paris
Children:
One son
Style:
Constructivism*

Lyubov was lucky: Her parents were well-off and loved art. She started having art lessons when she was only eleven. And she was quite sure that that was what she wanted to do!

It was an exciting time. Artists in Western Europe were coming up with new ideas. After all, now that photography had been invented, what point was there in simply copying reality in their pictures? And so new art styles arose. The Impressionists* captured the moods of light and examined the effect of colors; the Futurists* recorded on canvas their fascination with cars, trains, and other forms of technology; the Cubists* divided objects into their basic geometric forms.

Lyubov traveled to France and Italy and looked at all these new pictures. And then she went one step further and started painting shapes and colors only: Abstract* art had been born!

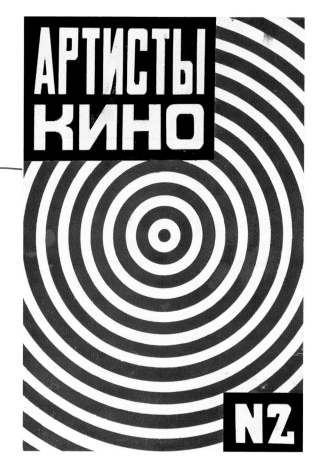

Cover design for a magazine, c. 1922–24
George Costakis Collection
(ArtCo. Ltd.)

Here is a cover design Lyubov created for a film magazine. See how bold her shapes and colors are. Striking poster and cover designs like these introduced her new kind of art to popular culture.

She abandoned the old way of painting because, at that time, many people in Russia longed for a new beginning—in their lives as well as in art. The Russian Revolution* had been brewing for several years and, in 1917, the Tsar of Russia was forced to abdicate and the Communist* Party seized power.

At last! Lyubov wanted to use her art to help convince everyone about Communism. She taught art and design, worked on stage sets for the "Theater of the Revolution" and created fabrics and clothes. She painted posters, illustrated books, and even produced china. She also felt that everyday objects had to be in line with the "new spirit" of Russia.

At the beginning, most people had no idea that before long the Communist Party would seize complete power and persecute many people. Lyubov did not live to see that as she died in 1924 at the age of only 35.

Choose a number of everyday objects and arrange them on a table. Look at them carefully and work out what their basic shapes are and divide them up according to their geometry, such as circles, ovals, trapezoids, or rectangles. Then try painting these shapes or take a photo of the arrangement. If you print out the photo on ordinary paper you can paint over it emphasizing the shapes which you can see.

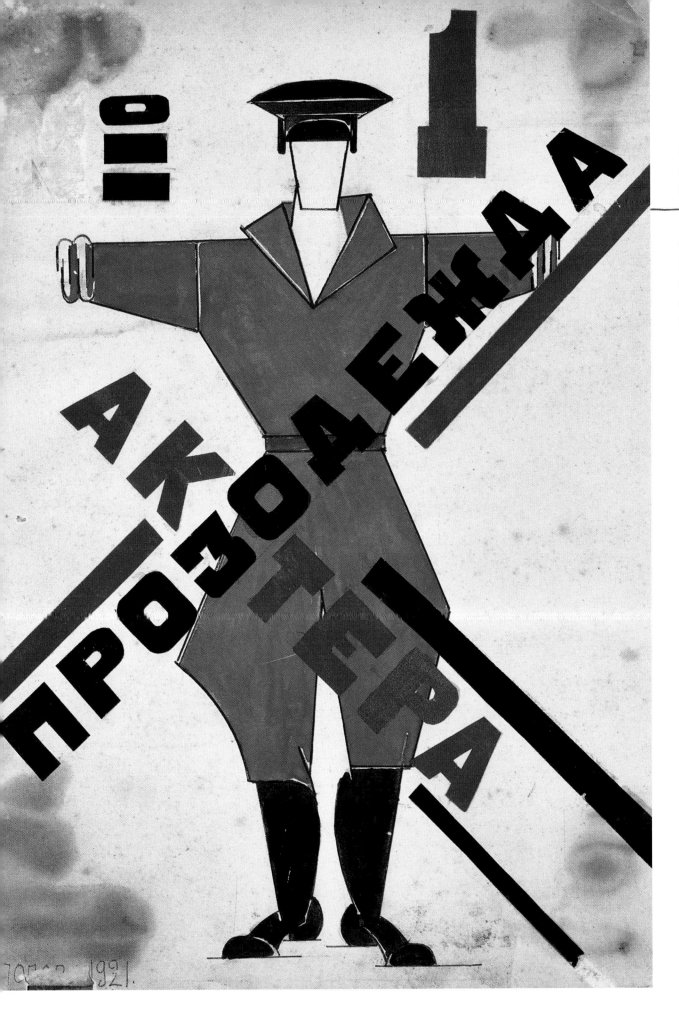

**Work Wear for Actors
No. 1, 1921**
Museum Ludwig, Cologne

This suit is simple and functional—like a workman's outfit. In the future it would not be the aristocracy who set the tone, but ordinary workers.

1876 1879 1882 1885 1888 1891 1894 1897 1900 1903 1906 190

Self-Portrait (Tamara in a Green Bugatti), 1929
Private collection

This self-portrait of Tamara de Lempicka appeared on the cover of the German fashion magazine "Die Dame." As you can imagine, the painting became famous overnight—and Tamara with it. That was exactly how people imagined a modern, independent woman to be!

Good to know
Tamara's ideal was to bring out the beauty in all things—especially in art. She considered pictures in the modern style of her time to be ugly. On the other hand, she didn't want to be old-fashioned either. And so she used all the tricks of the latest styles which artists had developed. Elements of Cubism* fitted into her overall scheme because Tamara liked the cool effect they created. Cubism dissects objects into their basic geometric forms. Can you think of any other reasons why this picture seems so cool?

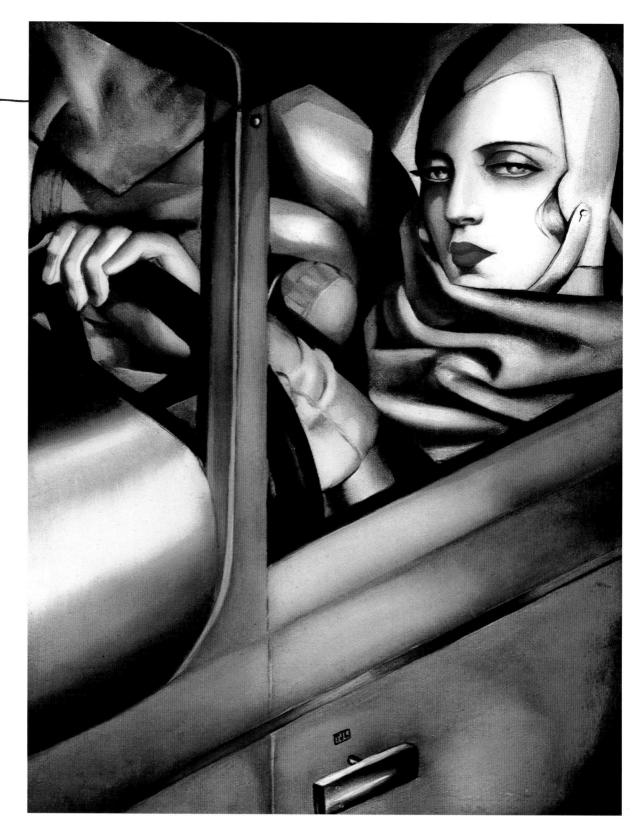

1914–1918 World War I
1917 Russian Revolution
1929 Great Depression
1925 First Art Déco Exhibition
1939–1945 World War II

1912 1915 1918 1921 1924 1927 1930 1933 1936 1939 1942 1945

Tamara de Lempicka–The woman who "invented herself"

She was beautiful and talented. She was also ambitious and self-confident—but above all she had one goal: she wanted to become rich!

Born:
May 16, 1898 in Warsaw
Died:
March 18, 1980 in Cuernavaca, Mexico
Lived in:
Warsaw, Lausanne, St. Petersburg, Paris, Los Angeles, Cuernavaca
Painting style:
Art Déco*

And so Tamara de Lempicka followed her dream, step by step. Like a modern marketing expert she invented the "product" Tamara. People who bought Tamara's pictures also purchased her inimitable style. She was a cool beauty, bold, self-confident, and free—a modern woman of the 1920s!

The rich and famous people in Paris were fascinated by this glamorous personality who had suddenly appeared in their midst. Where did she come from? Nobody knew for sure because Tamara surrounded herself with an aura of mystery. Her house in Paris—three stories high and decorated in the Art Déco* style—was not only her home but also her studio. It was here that she painted and gave parties for Parisian High Society.

Tamara originally came from Poland and was married to a lawyer in St. Petersburg in Russia. When the Russian Revolution* broke out there in 1917, the couple fled to Paris. Here, it was Tamara who earned the money for both of them.

Her pictures were like her. "... track down the elegance in your models," was her motto. And people loved to be painted by her—after all, who would not wish to be as elegant as Tamara?

Quiz
Do you know the name of a famous woman artist living today who has stylized herself many times and who is good at marketing herself with the help of the media? A hint: she doesn't paint like Tamara—she is a singer.
(Answer on page 46)

Born:
July 6, 1907 in Coyoacán, a suburb of Mexico City

Died:
July 13, 1954 in Coyoacán

Lived in:
Coyoacán and between 1930–33 in the United States

Painting style:
Individual, based on folkloric votive art*

Frida Kahlo–A diary of Mexican pictures

She was often lonely and was constantly in pain. In her paintings she pours out her emotions, which sometimes seem on the verge of tearing her apart.

It happened in Mexico City: Frida was on her way home from school when the bus in which she was traveling crashed into a streetcar. She was very badly hurt and for nine months had to lie in a plaster cast. That was when she began to paint—lying down. Her mother fixed an easel at an angle above her bed and hung a big mirror above her head. That meant that Frida always had a model she could paint. She had lots of time to study her face. Perhaps that is why more than half of her pictures are self-portraits.

Later on she fell in love with the artist Diego Rivera and married him. He was also a Communist, and fought to have property redistributed between the rich and the poor. He painted large murals of the Revolution* which took place in Mexico from 1910–20. Frida painted pictures of things which did not really exist. Or have you ever seen a man growing out of the trunk of a tree? Or a baby with an adult's head? And yet Frida still portrayed reality in her paintings—but in her own very special way.

You can understand some of her paintings instinctively. Others are easier to grasp if you know something about them. For example, the Aztecs, the people who lived in Mexico before it was conquered by the Spanish, believed that opposites belonged together: The moon belongs together with the sun, light with darkness, life with death. Frida Kahlo was a quarter Mexican-Indian herself. She was very proud of the fact and very often wore traditional Mexican clothes to show everyone.

1907–1954 Frida Kahlo

910–1920 Revolution in Mexico 1925 Frida is badly injured in an accident 1939–1945 World War II
 1914–1918 World War I 1924 André Breton produces the "Surrealist* Manifesto"

1912 1915 1918 1921 1924 1927 1930 1933 1936 1939 1942 1945

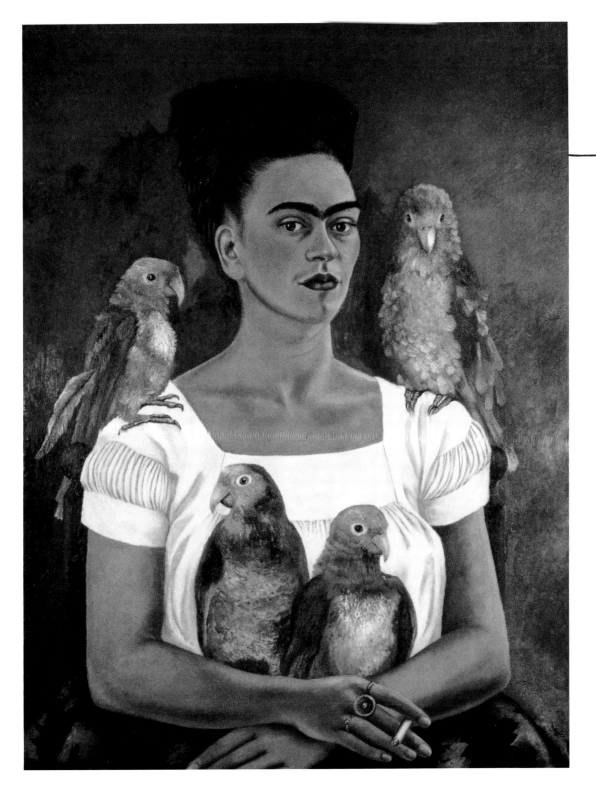

I and my Parrots, 1941
Collection of Mr. and Mrs. Harold H. Stream, New Orleans

Frida liked to wear her hair in traditional Mexican-style, as you can see in this picture. She kept parrots and many other animals as pets.

Good to know
In the Hindu faith parrots are the creatures which carry the god of love, Kama. Frida had just fallen in love when she painted this picture.

**Roots (The Pedregal),
1943**
Private collection,
Houston, Texas

Frida is wearing a dress
typical of the Tehuana
Indians. The Tehuana
women were very
strong—as strong as
Frida would have liked
to be herself. She is lying
on the bare ground
but luxuriant plants are
growing out of her body.
What do you think that
could mean? Frida felt
very close to her country,
the Mexican-Indian
culture, and nature.

Tip
Her former home and
studio, the Blue House
in Coyoacán, is now a
museum:
Museo Frida Kahlo,
Casa Azul, Londres 247,
Col. del Carmen.

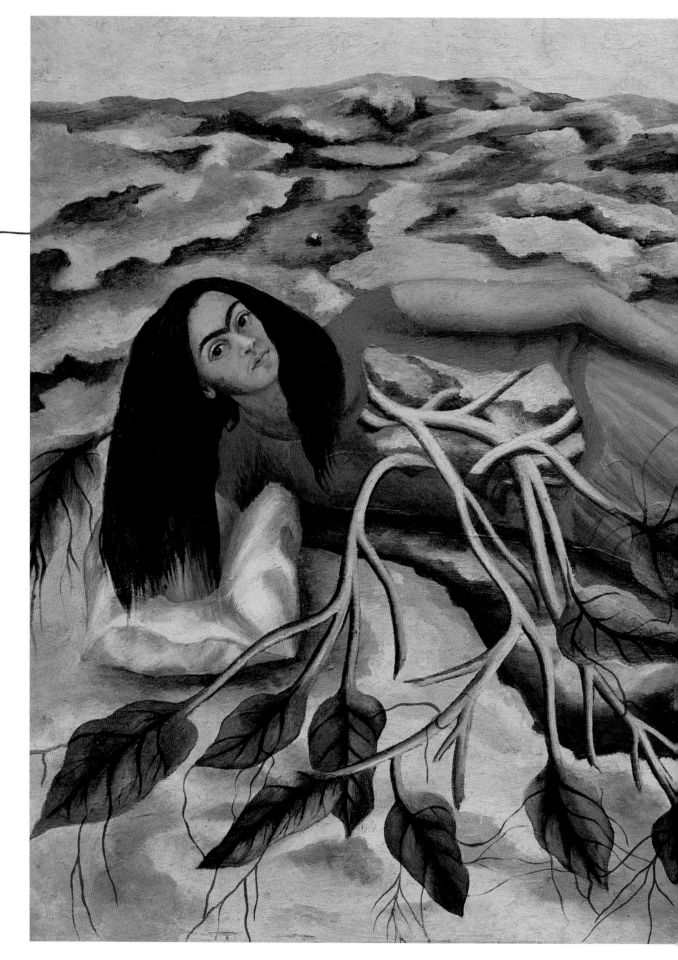

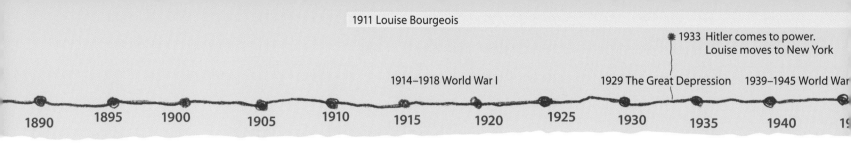
1911 Louise Bourgeois

1933 Hitler comes to power.
Louise moves to New York

1914–1918 World War I 1929 The Great Depression 1939–1945 World War

1890 1895 1900 1905 1910 1915 1920 1925 1930 1935 1940 19

The Spider

"Beaufort 2006" art happening in Ostend, Belgium

Louise's huge sculpture *Maman* has gone on its travels. It spent the entire summer standing over the grave of the Belgian artist James Ensor in Ostend. What did a spider have to do with Louise's mother? Well, for example, Louise's mother wove precious rugs and here, above the grave, it looks like a protective tent, don't you think? Maybe Louise wanted to say something about how important James Ensor's mother was for him.

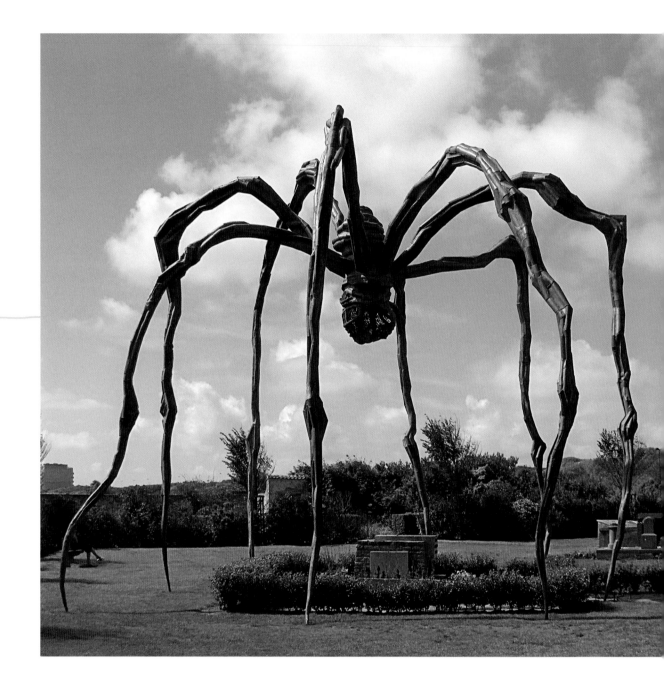

Would you also like to experiment too? You can buy plaster of Paris, for example, in shops that sell art supplies. Mix the powder with water and then you can start. You can pour the plaster into a mold and then work on it after it has gone hard. Or you can let it drip or press attractive objects into it. Try it out and you'll come up with some more ideas too.

47–1954 McCarthy era: Communists* are persecuted politically in the United States. Louise is also required to defend her views

1965–1973 The United States fights in the Vietnam War

1970s Women in the United States fight for their rights

1969 The first man lands on the moon

950 1955 1960 1965 1970 1975 1980 1985 1990 1995 2000 2005

Louise Bourgeois-A solitary figure between two worlds

Throughout her long life, Louise Bourgeois has created works of art to find out more about the mysterious dark years of her childhood.

Louise was a girl who tried to be good but who found the world confusing. As she grew up she started putting her thoughts down on paper and began to paint. She was determined to explore one particular question: "What am I like?" She soon sensed that her art could be more "real" than just a picture. She therefore began to progress beyond the boundaries of the pictures she had painted and filled entire rooms with her art.

Wooden rods, for example, could be used to represent people. The effect was different, depending on where they were positioned in the room. And, when the beam of a spotlight passed across them, it even looked as if they were moving.

Louise has tried out lots of things, including new materials: In addition to bronze and marble she also uses plaster, cement, latex, fabric, plastic, and rubber in her artworks.

Louise was born in 1911 and is now nearly a hundred years old. She is one of the greatest woman artists of our time.

Born:
December 25, 1911 in Paris

Lives in:
Paris, Antony (southern Paris), New York

Children:
Three sons

Style:
Louise has always been keen to try out new things and has followed her own artistic path

1933 The National Socialists (Nazis) come to power

1914–1918 World War I

1903 1906 1909 1912 1915 1918 1921 1924 1927 1930 1933 1936

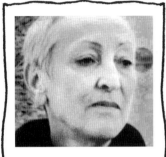

Born:
October 6, 1913 in Charlottenburg, now a district of Berlin
Died:
November 15, 1985 in Basle, Switzerland
Lived in:
Berlin, Basle, Bern
Style:
Surrealism*, inspired by her own dreams

Meret Oppenheim– Furry sensations

She was just twenty-three when she managed to cause a sensation: She became world famous with her object *Breakfast in Fur.*

"I want to become an artist," decided Meret Oppenheim and went to Paris when she was eighteen. There she made contact with the Surrealists and showed *Breakfast in Fur* at one of her exhibitions in 1936. What a sensation! The work was so good that the Museum of Modern Art in New York bought it.

And then? For a while, not much was heard of her. She could have become the "cover-up artist" covering all objects in fur! But she didn't want to get "stuck in a rut." She chose to remain true to herself and to her determination to express her ideas. And so, for almost twenty years, she achieved little that would stand up to her own critical gaze.

My Nanny, 1936
Moderna Museet, Stockholm

When she created this object Meret Oppenheim was thinking about her former nanny who was dressed in white.

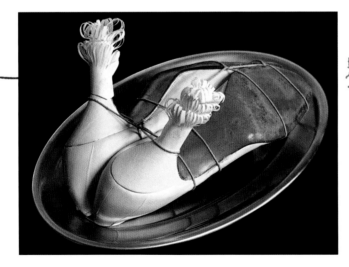

Why not join in?
You and a friend can play a game together using this object: Each of you takes it in turns to say what the object makes you think of—one after the other, very fast.

(You will find some suggestions on page 46).

1960s Student protest movement
1970s Meret Oppenheim actively supports women's rights
1956 Rock-and-roll 'King' Elvis Presley becomes a cult figure
1939–1945 World War II

1939 1942 1945 1948 1951 1954 1957 1960 1963 1966 1969 1972

Object (Breakfast in Fur), 1936
The Museum of Modern Art, New York

The idea of fur in our mouth is not at all pleasant! It somehow doesn't fit together. The object makes us hesitate, it arouses associations* and feelings. Something which is very hard to explain.

But then, suddenly, the ideas started to bubble forth again. She produced sculptures and objects*, drawings, paintings, collages*, poems—powerful artworks which had a tremendous effect. They were displayed in exhibitions and aroused the interest of the public once more.

1900 1905 1910 1915 1920 1925 1930 1935 1940 1945 1950 19

Bon Appetit!, 1979
Private collection

For a while Niki created "mothers" like this one, who "swallowed everything." She looks rather fed up, armed with a fork and with her lap dog. Strangely enough, her face does not curve outwards, but is concave.

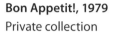

Quiz
What exactly is a "Nana?"
(Answer on page 46)

Good to know
Niki was particularly fond of heavy women. The cook in her family was also "fat, beautiful, and warm."

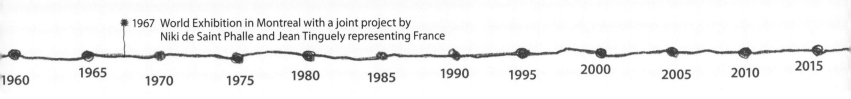
Niki de Saint Phalle— And her jolly "Nanas"

Niki's "Nanas" run, dance, and do gymnastics. High-spirited, fat, curvaceous, and infinitely feminine, they bounce their way through the world full of the joys of life!

Load, aim, fire! Bull's-eye! Paint pours out over the white relief*. And again. Niki has hidden bags of paint under the plaster and each time she shoots and hits, they burst open. The artist is a picture of total concentration as she completes her work of art surrounded by spectators. It was with "actions" like this that Niki de Saint Phalle catapulted herself into the lime-light of the international art scene.

Niki was venting to her anger by shoot-ing at her artworks. Although she was aiming at her plaster figure, mentally she was shooting at everything which had hurt her deep down inside and at the ways of the world which gave women so little freedom in those days.

Niki needed all her strength to overcome her anger and sadness. She did it by creating art. And what a transformation took place! With her larger-than-life figures known as "Nanas" she soon conquered the hearts of the public. They were powerful, amusing, and lively and they made the world a little more cheerful and colorful. A man called Jean Tinguely, who was also an artist, helped her in her efforts.

Born:
 October 29, 1930 in Neilly-sur-Seine (a suburb of Paris)
Died:
 May 21, 2002 in San Diego, California, USA
Lived in:
 New York, Paris, Switzerland, Capalbio (Italy), San Diego
Children:
 Daughter Laura and son Philip, as well as a granddaughter and a great-grand-daughter
Style:
 Member of the group of Nouveaux Réalistes*

Dancing Black Nana, 1965/66
Private collection

Here is one of those "Nanas." Niki loved soft lines, curves, waves, in fact everything round—but not circles. It all had to be not quite perfect, just like real life.

37

Magician and High Priestess in the Tarot Garden, 1983
Tuscany

Here the high priestess, the female figure, is the light blue body, and the magician is male and has a glittering silver head. The "Wheel of Fate" which clanks noisily as it turns in the pond was designed by Jean Tinguely.

Quiz
Tinguely believed that fate brings us happiness and good fortune. How does he show this?

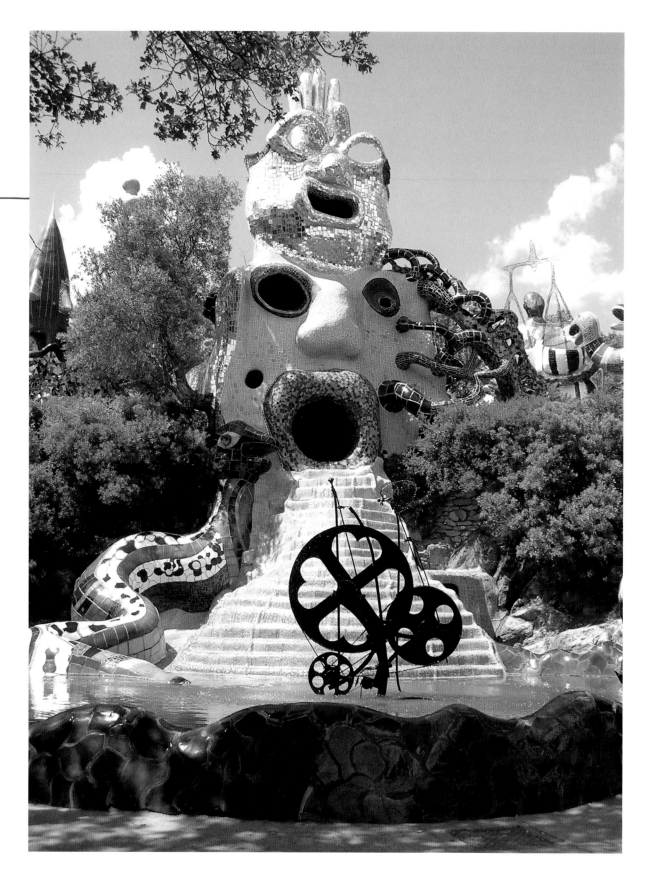

Niki liked working together with other people and children often helped her to paint her figures in bright colors. She designed playground figures for them to crawl inside, such as an enormous head with three tongues which you could slide down. Or a dragon several meters long with little playrooms inside.

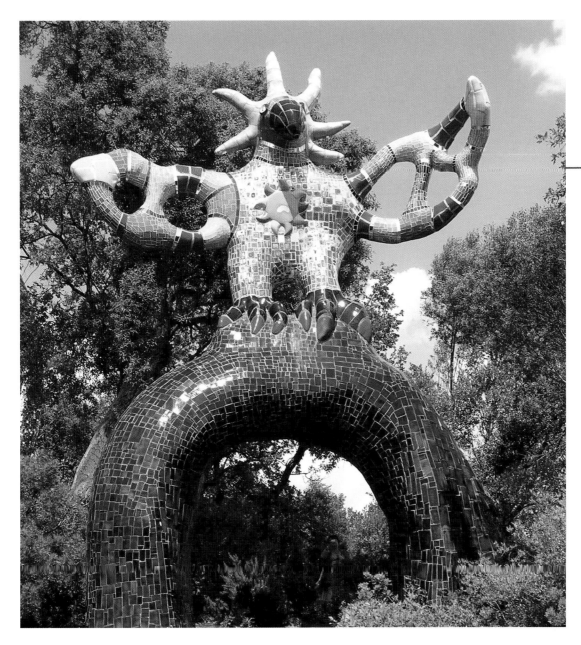

The Sun in the Tarot Garden, 1983
Tuscany

The firebird, who also stands for the sun god, is sitting on the blue arch of heaven. In the tarot he is on card number nineteen. The combination of numbers 1 and 9 stands for the beginning and for complete happiness. What a friendly reception for visitors to the Tarot Garden.

Tips
Niki did not really like museums. So you can see lots of her works out in the open air.
She designed the grottoes in the Herrenhäuser Gardens in Hanover and also placed three "Nanas" on the banks of the River Leine.
The Tarot Garden is in Capalbio in Italy: www.nikidesaintphalle.com
On the Place Igor Stravinsky in Paris there is also a beautiful fountain with sculptures by Niki and Jean Tinguely.

But her biggest project was the Tarot Garden in Tuscany with its bright figures which you can go into. Here you will also find the biggest "Nana" of all, which for Niki represented the fulfillment of a dream. She wanted to live inside one of her "Nanas" too, because for her they stood for the "Earth Mother" and "security." Step inside and see for yourself!

You can make your own figures just like Niki. You will need empty plastic bottles—preferably nice round ones –papier mâché, and bright paint. Use the papier mâché to mold your sculpture around the plastic bottles and knead it to form the details as required. Let it dry and then paint it. Presto!

Crest of a Wave, 1964
The British Council,
London

Do you know the feeling
when walking along the
shore watching the waves
as they break? It can make
you feel quite dizzy—the
same feeling you get
when you look at this
picture.

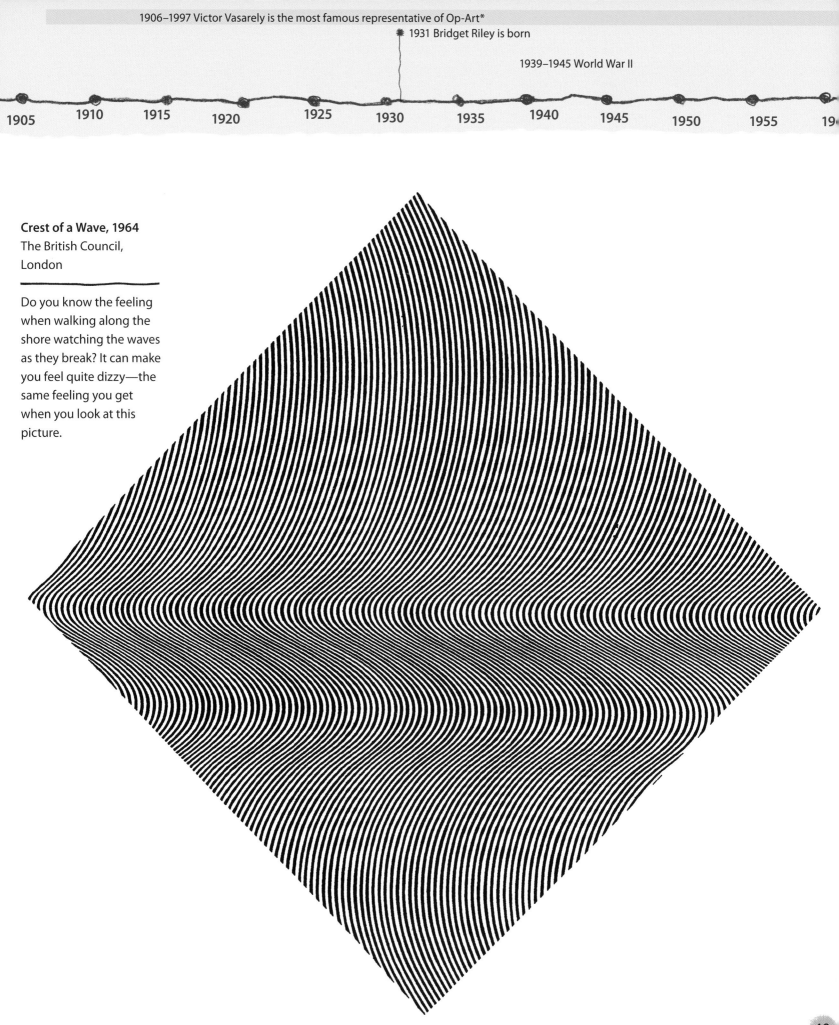

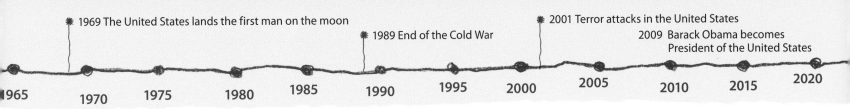
Bridget Riley–Out of the corner of the eye

Born:
April 24, 1931 in London
Lives in:
London, Cornwall, and Vaucluse, southern France
Painting style:
Op-Art*

Sometimes, when Bridget Riley is out in the countryside, she can feel the landscape vibrating in front of her eyes.

Do you know that feeling too? It comes quite suddenly, out of the blue. You can't really explain it and it may disappear again immediately. It's like "seeing something out of the corner of your eye." Like the way sunlight dances on the ripples on the surface of water, or catching sight of a cornfield waving in the summer wind. What you experience is the feeling you get when you can't quite capture what you have seen in your mind's eye.

It was this way of seeing things that Bridget Riley wanted to create in her work. And so she started painting black-and-white pictures with geometric patterns which make our eyes flicker. She never studied or worked out the optical effects, but developed them through her painting.

Later she slowly started to introduce color. First of all she only included shades of gray in her pictures, but then she began to use the entire range of colors. Her colored pictures are more "inhabitable," as Bridget Riley put it—no longer quite so confusing.

Tip
On the website of the Karsten Schubert Gallery in London, where there are often exhibitions of Bridget Riley's work, you can see some more pieces by the artist: www.karsten-schubert.com

See for yourself
Try playing around a bit as you look at this picture. First cover up one eye and then the other. Blink once so that you almost close your eyes. Or focus your eyes like a wide-angle lens so that you can take in your whole field of vision. It is amazing how the picture changes!

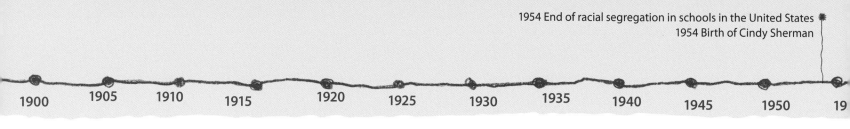

Born:
January 19, 1954 in Glen Ridge, New Jersey, USA

Lives in:
New York (mostly). Her "Historical Portraits" were produced in Rome

Style:
Cindy Sherman is one of the most important representatives of staged photography

Cindy Sherman– The quick-change artist

She takes delight in shocking people with grotesque* ugliness by holding a mirror up in front of them.

Cindy Sherman has great fun producing her art: dressing up in order to shock people—even as a child she used to love doing that! Wigs, make-up, clothes, scarves, fabric, jewelry, and shoes—these are the kinds of things she uses. And then she takes her camera to record the results of her transformations.

She takes photos of entire scenes which she records in static pictures: Cindy Sherman as a film star, a housewife, a teenager, as the Virgin Mary standing at the sink in front of a mirror, on a tiled floor, in front of flowered wallpaper—she seems to have an endless imagination!

But wait a minute. Is it always Cindy Sherman that we see? Not at all! The people she photographs could be any of us. Because day by day we obediently play out the roles expected of us. But what do these costumes that she wears have to do with us? By exaggerating various role characteristics, Cindy Sherman makes us see how ugly, false, and artificial they make us.

Why not arrange a photo session? Pick out some costumes, have your camera ready and off you go!

42

1960 John F. Kennedy becomes President of the United States

1969 The United States lands the first man on the moon

2001 Terror attacks in New York

2001–2009 George W. Bush is President of the United States

960 1965 1970 1975 1980 1985 1990 1995 2000 2005 2010 2015

Untitled #424

Cindy usually produces series of pictures on a particular subject. For example, there is a whole series of pictures of clowns. What is the person like who is hidden behind the mask? That is what Cindy aims to find out here.

Glossary

ABSTRACT Abstract art does not portray reality but is a composition of colors and shapes. Wassily Kandinsky was one of the most important founders of abstract painting which emerged at the beginning of the twentieth entury.

ART DÉCO is a style found in design and art during the 1920s and '30s. It was used in architecture, for furniture design, in fashion, and for household objects. It favored elegant shapes and the use of precious materials. The lack of shadows and naturalness gives this type of art a modern, often two-dimensional appearance.

ARTISTS' COLONY A group of artists living and working together in the country. The expression is also used to indicate a rejection of the painting style taught by art academies. The first artists' colony was formed in 1830 in Barbizon, France. Others followed later in England and Germany.

ASSOCIATION An often unconscious linking of thoughts, emotions, moods, and impressions. For example, it could be that you associate a particular feeling with a certain smell.

BAROQUE The Baroque era lasted from about 1600 to 1750. In those days, people liked a lively picture structure in large pictures with curving lines and a dramatic use of light and shade. One of the fashionable trends at the time was also the painting of still lifes* and flowers.

CÉZANNE, PAUL was a French painter who lived from 1839 to 1906. He was the first artist to divide objects up into their geometric forms. For him, painting from nature did not mean copying something but rather expressing his feelings about it.

COLLAGE Coller is the French word for "to glue." In a collage newspaper cuttings, photos, colored paper, ribbons, etc. are stuck onto a background. The special thing about a collage is often the fact that things which do not really belong together may be put side by side.

COLONY Following the discovery of America, European countries took possession of land on other continents—America, Africa, Asia, and Australia. The original inhabitants were deprived of power and repressed, and the country's resources, such as gold and fertile land for growing sugar cane, for example, were exploited.

COMMUNISM was the idea of a form of government in which all factories and farms were owned by the people as a whole. The earnings produced from this work also belonged to everyone. The Communist Party took over the organization of everything. The idea was to prevent a small number of people acquiring too many possessions and too much power and then oppressing the poor.

CONSTRUCTIVISM is an abstract* painting style which began in Russia. The Constructivists wanted to abandon the rules which had previously applied to painting and make a fresh start. That was how they had the idea of only painting geometric shapes and fields of color.

COPPERPLATE ENGRAVING is a form of printing. Lines are scored onto a copper plate and then covered with ink. A damp sheet of paper is pressed onto the copper plate and the ink drawn out of the grooves.

CUBISM A style dating from the beginning of the twentieth century. Objects and figures are divided into geometric shapes and shown from several different angles at the same time. The laws of perspective were ignored.

DADAISM The Dadaists rejected everything which other people found "normal"—in art as well as in life. They often used their art to make fun of such "normality." They chose the baby word "Dada" on purpose to describe their art.

ETCHING Similar to copperplate* engraving, but carried out on zinc, brass, iron, or plastic. An etching is made using acid which bites into the exposed areas made by a drawing on a waxed metal plate. The exposed lines are inked and a print is then made.

EXPRESSIONISM was a style that emerged at the beginning of the twentieth century. Artists attempted to "express" their experiences in their artworks by using colors and shapes which began to free themselves from actual objects and develop a significance of their own. The Expressionists always searched for the essential element in a subject and abandoned the traditional use of perspective.

FUTURISM The Futurists were fascinated by the rapid developments of technology at the beginning of the twentieth century. They were also interested in finding an answer to the question of depicting movement.

GROTESQUE As an adjective grotesque means strange, distorted, eccentric. As an art form, the grotesque is a distorted, exaggerated representation which arouses feelings of ridicule and disgust at the same time. Objects are often combined with each other which do not really belong together, such as a body which is both human and animal.

IMPRESSIONISM developed between 1860 and 1870 in France. The Impressionists painted outdoors in order to capture natural light on their canvases. Instead of just mixing paint on their palettes they placed dots of pure color next to each other which produced a more intensely brilliant effect.

The mixing of colors takes place in the viewer's eye. The pictures were often produced quickly, rather like sketches.

LITHOGRAPHY is a method of printing known as planography. It functions because water and wax repel each another. A drawing is transferred to a limestone plate using a fatty crayon. Water is applied to the stone and then ink is rolled across the entire surface. The damp surfaces repels the ink but the fatty drawing absorbs it. In this way the drawing can be printed.

MONARCHY The word monarchy means rule by a single person and is a form of government. A king, queen, or emperor makes decisions for the country which he or she rules. A monarchy can be absolute, in which case the sovereign has complete power; it can be constitutional, in which case the monarch's power is restricted by laws (the constitution); or it can be parliamentary, in which case the laws are determined by parliament and the monarch has a representative task.

NOUVEAUX REALISTES This group of artists was formed during the early 1960s. They abandoned abstract* art and wanted to integrate the reality of daily life into their art by means of new techniques and materials. They contributed to the development of Object art* and Action art.

NOVEMBER REVOLUTION The refusal of sailors to fight another sea battle at the end of World War I developed into a Germany-wide revolt against the Emperor. The revolution ended on August 11, 1919 with the constitution of the first democratic republic in Germany, the Weimar Republic.

OBJECT ART Object art is an art form in which one or more objects—sometimes slightly altered—are

declared to be a work of art. Its roots lie in Dadaism*, but it was not properly developed until the end of the 1950s.

OP-ART Op-Art, an abbreviation for Optical Art, is a way of painting which arose around 1960. With the help of geometric shapes, effects of movement and flimmering are produced in the viewer's eye. They are the result of optical effects (or illusions): our brain processes what our eyes see incorrectly.

RELIEF A representation which is raised three-dimensionally above the background.

RENAISSANCE The French word *renaissance* means "rebirth." Many thoughts and artistic ideas from Antiquity were "reborn"—or rediscovered. It became customary to think more freely than had been possible during the Middle Ages. People wanted to explore the world about them.

REVOLUTION brings about a violent political change. People or a group of people fight against a government, a monarchy* or a dictatorship.

RUSSIAN AVANT-GARDE Between 1910 and 1922 the artists of the Russian Avant-Garde renewed their art and catapulted themselves to the forefront of the international scene. They developed abstract* painting—especially Kasimir Malevich, who became famous for one picture in particular: a black square he painted on a white background.

STILL LIFE A number of objects are arranged—for example on a table—and then painted.

SURREALISM The Surrealists attracted a great deal of attention during the 1920s and '30s. They linked together familiar objects in an unfamiliar manner to produce surprising, mysterious pictures—rather like in a dream.

VOTIVE ART Pictures which faithful Catholics hang up in church as a thank-you to a particular saint in a particular situation. The pictures tell the story in a simple manner, usually with a caption.

WITCH HUNT From about 1450 until 1750 women who were seen as "strange" for whatever reason or who were thought to be "possessed by the devil" were accused of being witches. These "witches" were executed, often burned at the stake or drowned.

WOODCUT is a type of relief printing. Everything on a flat piece of wood which is not to be printed is cut away. Ink is put on the remaining raised surfaces and the image printed.

WORLD EXHIBITION International exhibition in which countries can show their culture and their achievements in technology, industry, crafts, and art.

Answers to the quiz questions

page 5: Lucia: And—checkmate! Minerva: Whoops. Europa: Heehee, you didn't see that, did you? Maid: Now I must have a look too.

page 16: Oil paints in tubes. Before that oil paints had to be mixed in the studio from lots of ingredients. That was not possible outdoors.

page 27: Madonna

page 34: ... A roast goose with white cuffs ... high-heels served on a tray ... chicken drumsticks ... tied up or all dressed up ... white shoes for a bride Isn't it remarkable how much you can express in a single object? Do we think, see, feel all that at the same time?

page 36: A goddess of love and fertility, but also the goddess of war. The goddess Nana was greatly respected in Susa in Persia.

Library of Congress Control Number: 2009928438; British Library Cataloguing-in-Publication Data: a catalogue record for this book is available from the British Library; Deutsche Nationalbibliothek holds a record of this publication in the Deutsche Nationalbibliografie; detailed bibliographical data can be found under: http://dnb.ddb.de

© Prestel Verlag, Munich · Berlin · London · New York 2009

Portraits:
Sofonisba Anguissola, *Self-portrait on an Easle*, 1556, Muzeum Lancut, Zamek; Jakob Houbraken after Georg Gsell, *Portrait of Maria Sibylla Merian*; Mary Cassatt; Stanhope Forbes, *Elizabeth Adela Armstrong Forbes*, 1890, Collection of Newlyn Art Gallery on loan to Penlee House Gallery and Museum, Penance; Alfred Stieglitz, Georgia O'Keeffe; Lyubov Popova, Collection of Natalia Adaskina and Dimitri Sarabianov; Tamara de Lempicka, c. 1927; Nickolas Murray, Frida Kahlo, 1938/39; Louise Bourgeois in her Studio; Meret Oppenheim; Larry Rivers, Niki de Saint Phalle, 1980; Bridget Riley, 1971; Cindy Sherman.

Picture credits:
Akg: p. 30/31, 34 a., 40, 41; Bridgeman: p. 14–17, frontispiece; Doris Kutschbach: p. 38, 39; Larry Rivers: p. 37 a.; The Museum of Modern Art/SCALA Florenz: p. 35.

Prestel Verlag
Königinstrasse 9, 80539 Munich
Tel. +49 (0)89 24 29 08 300
Fax +49 (0)89 24 29 08 335
www.prestel.de

Prestel Publishing Ltd.
4, Bloomsbury Place, London WC1A 2QA
Tel. +44 (0)20 7323-5004
Fax +44 (0)20 7636-8004

Prestel Publishing
900 Broadway, Suite 603, New York, NY 10003
Tel. +1 (212) 995-2720; Fax +1 (212) 995-2733
www.prestel.com

Translated from German by Jane Michael, Munich
Project Management: Doris Kutschbach
Picture Editor: Rahel Goldner
Copyedited by Christopher Wynne, Bad Tölz
Design: Michael Schmölzl, agenten.und.freunde, Munich
Art Direction: Cilly Klotz
Production: Nele Krüger
Typesetting: Stephan Riedlberger, Munich
Origination: ReproLine Mediateam, Munich
Printing and Binding: Tlačiarne BB, spol. s r. o.

Printed in Slovakia on acid-free paper
ISBN 978-3-7913-4333-4